MANDALAS

Adult Coloring Books

3

Color Art Designs

Coloring is considered a form of art therapy. But coloring complex mandalas is very special. In 2011 a small study was conducted in the Midwest with 85 participants. They were split into 3 groups. One group colored complex mandalas, one did free form coloring and the third group colored complex patterns. The groups that colored the mandalas and patterns reported a decrease in anxiety. In 2012 the study was reproduced by another set of researchers who concluded that coloring a somewhat complex mandala substantially reduced general anxiety even more than coloring patterns. This type of coloring can produce a state of meditation which is highly beneficial to persons suffering from general anxiety.

Mandalas Volume 3 includes many complex patterns. If you are someone who suffers from general anxiety and like to color why not try some of the patterns in this book? You do not have to paint every little area. Just add your own ideas into the design. It's your book color it as you please. Use your choice of colors to express your feelings. If you choose to color the tiny areas in the image then you will need a pen with a .35 tip. A good set of gel pens will work without bleed. Some types of markers will cause bleed. The images are printed on one side of the book so if you use markers just put then some stock paper under your page to control any bleed.

According to the research it appears that coloring complex mandalas helps you shut out interfering thoughts and concentrate on your art. The excess of stimulation that is all around can very distractive. Coloring a mandala seems to shut out all that "noise" and the concentration works to calm the mind. Some of the mandala patterns in the book may look similar but if you look carefully you can see the differences. Each piece will be unique to you when you are finished with your art. So don't worry just start coloring!

Copyright

Copyright © 2016 by Color Art Designs

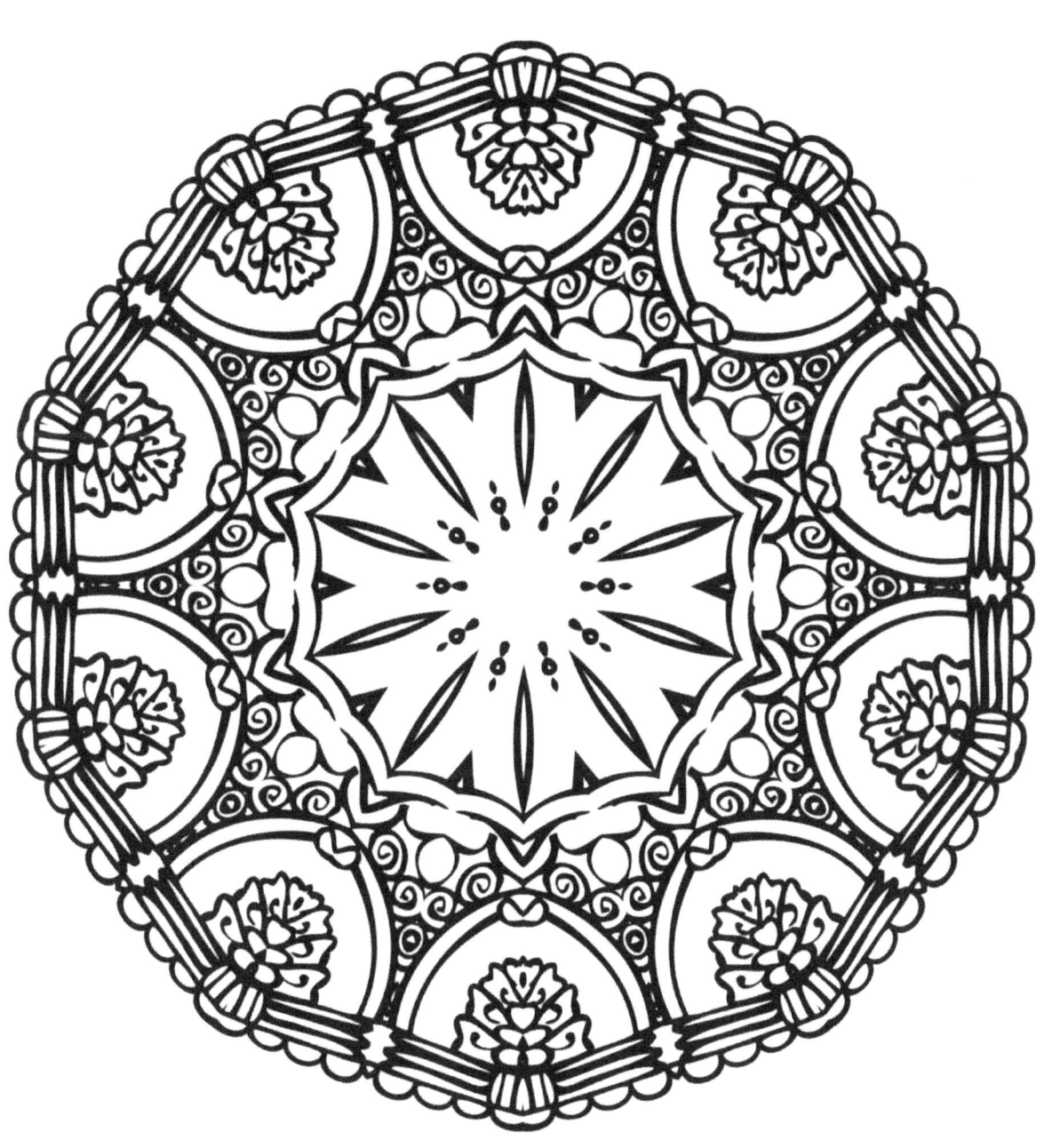

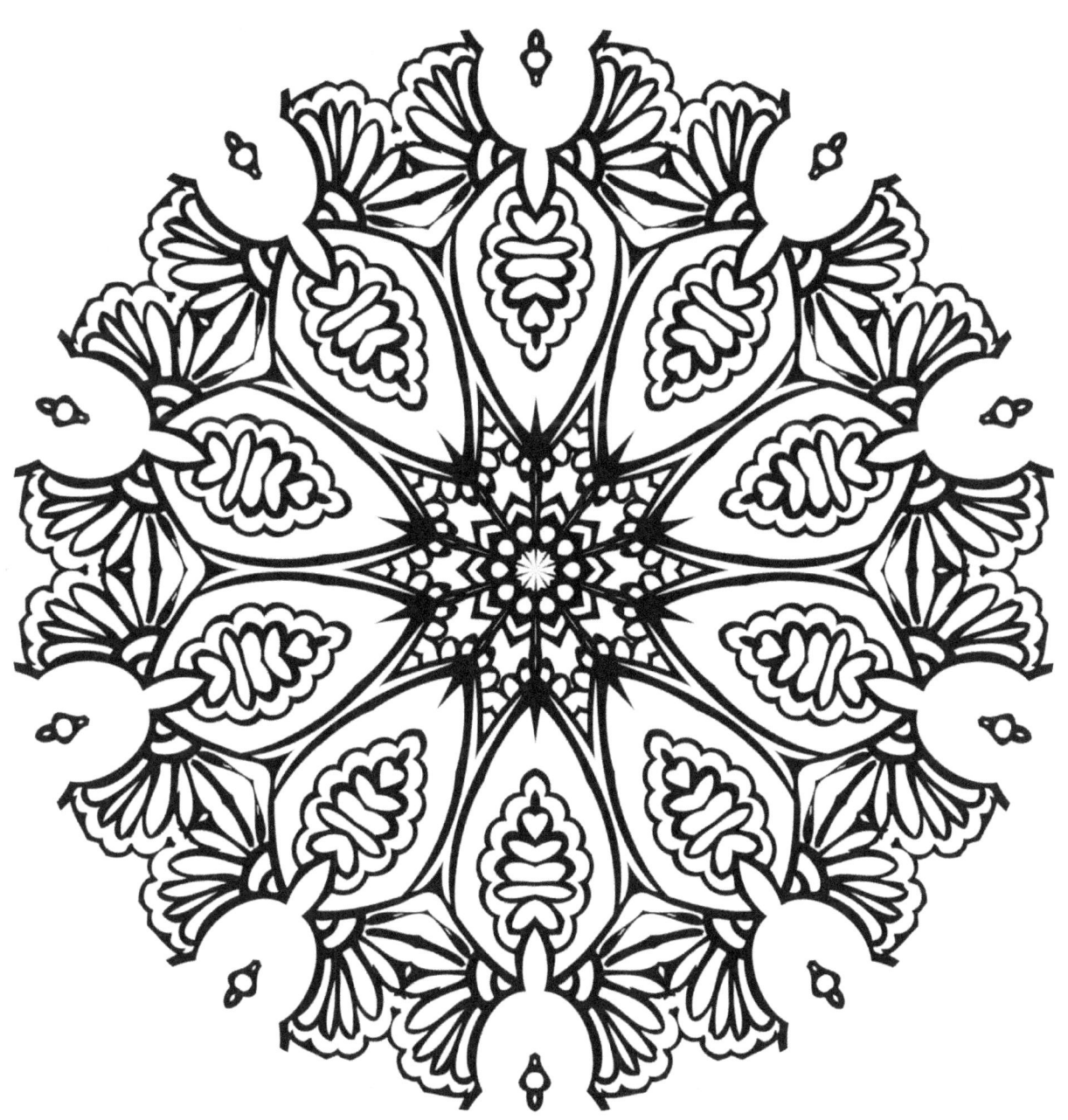

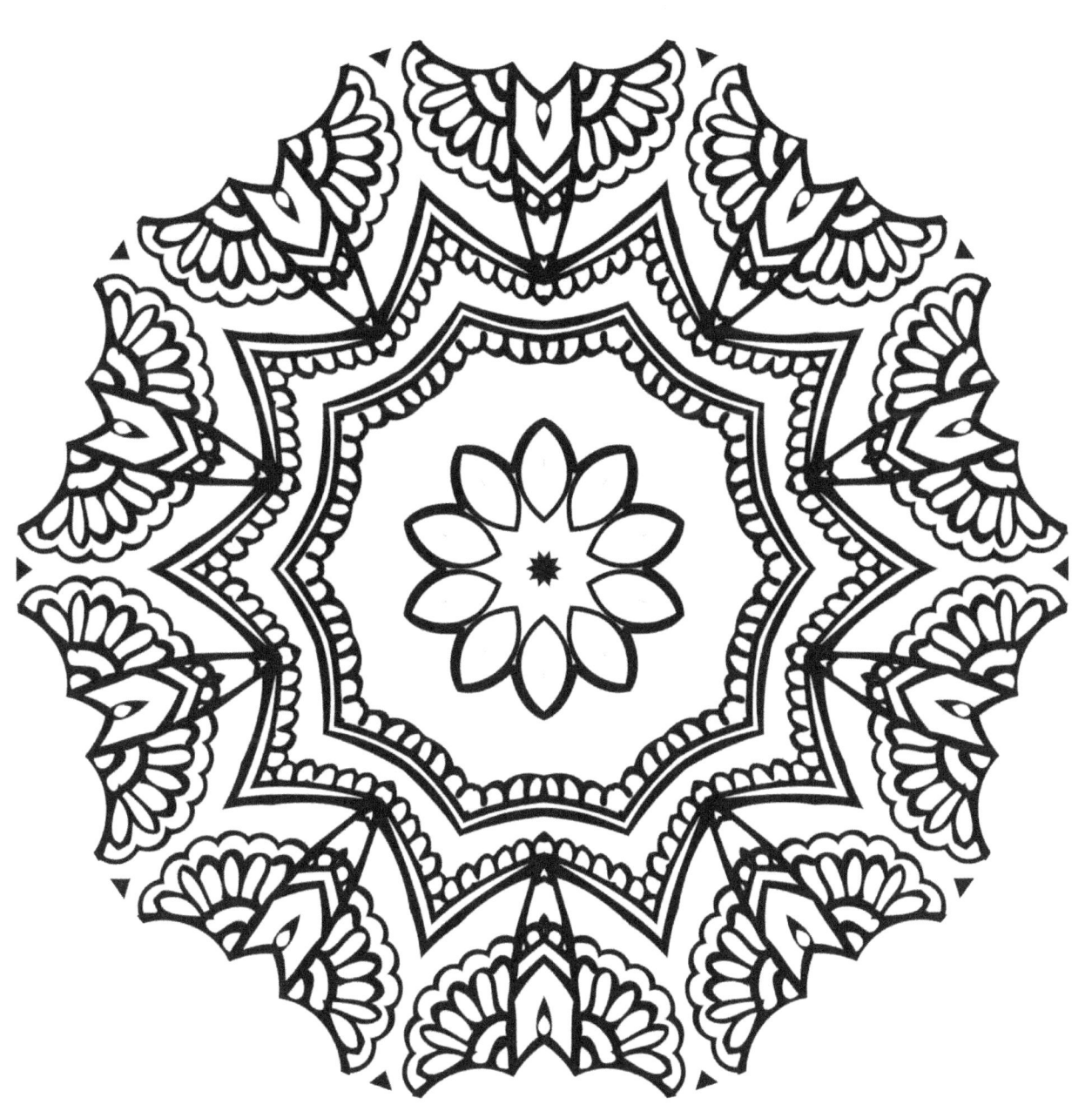

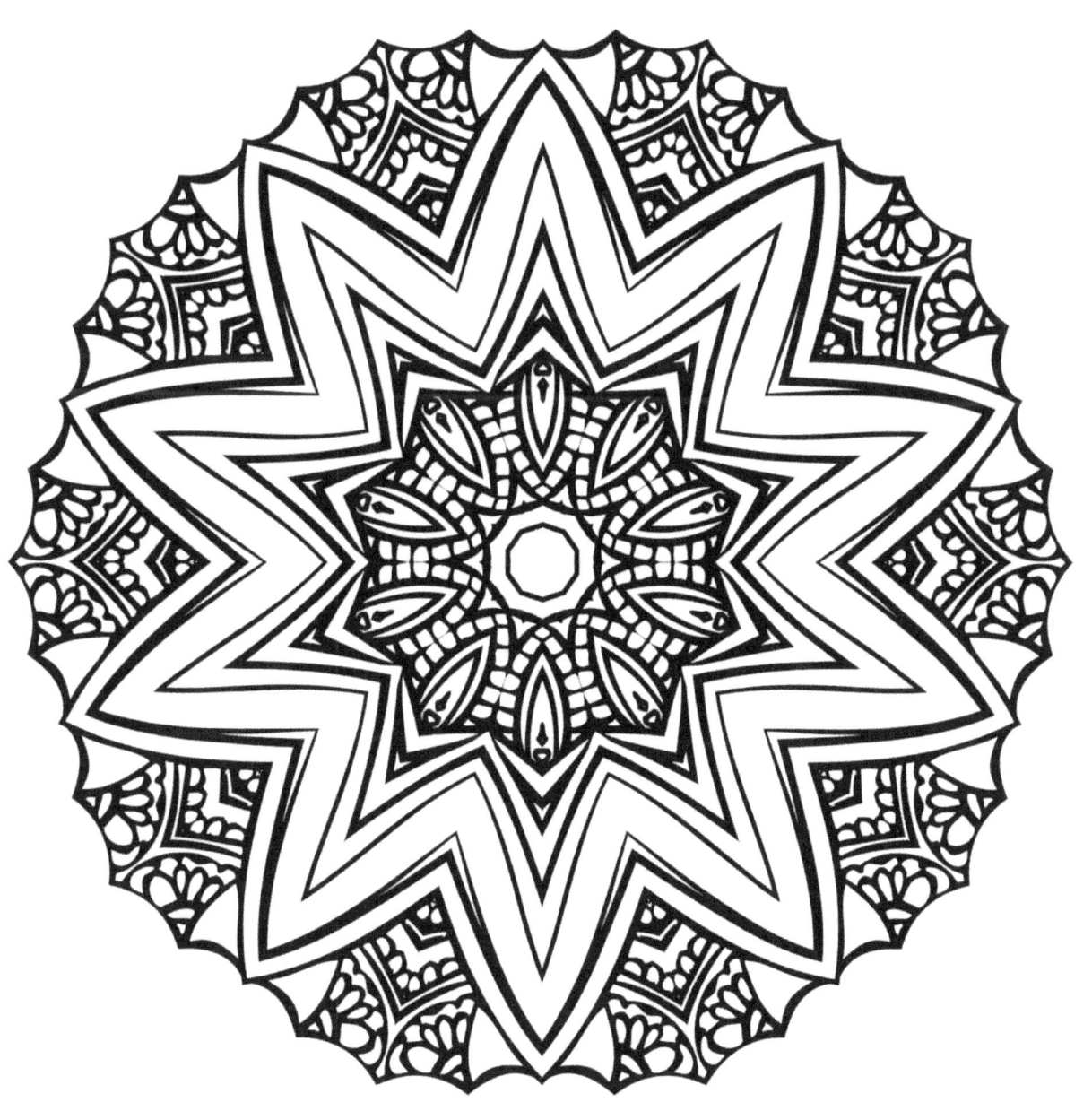

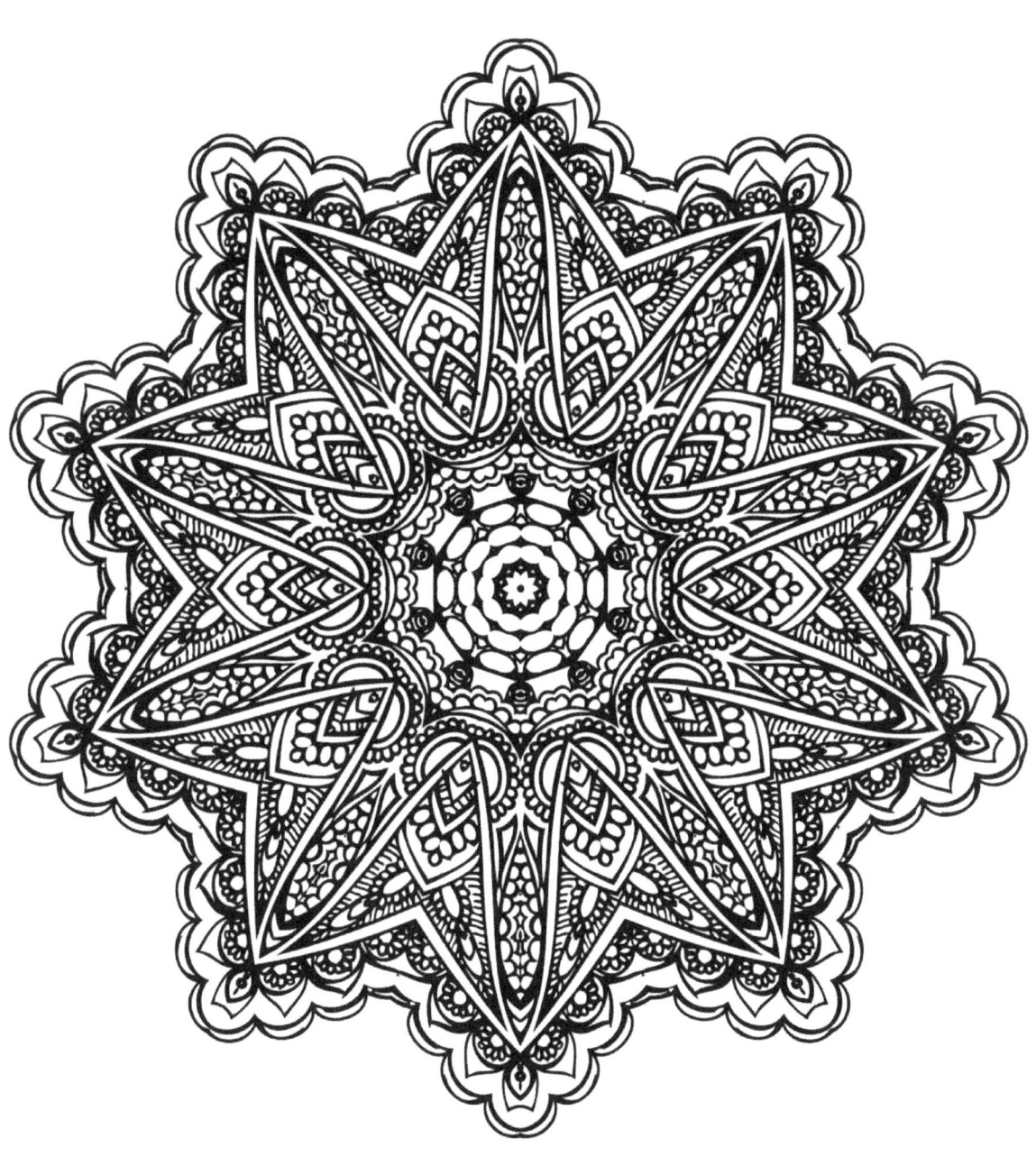

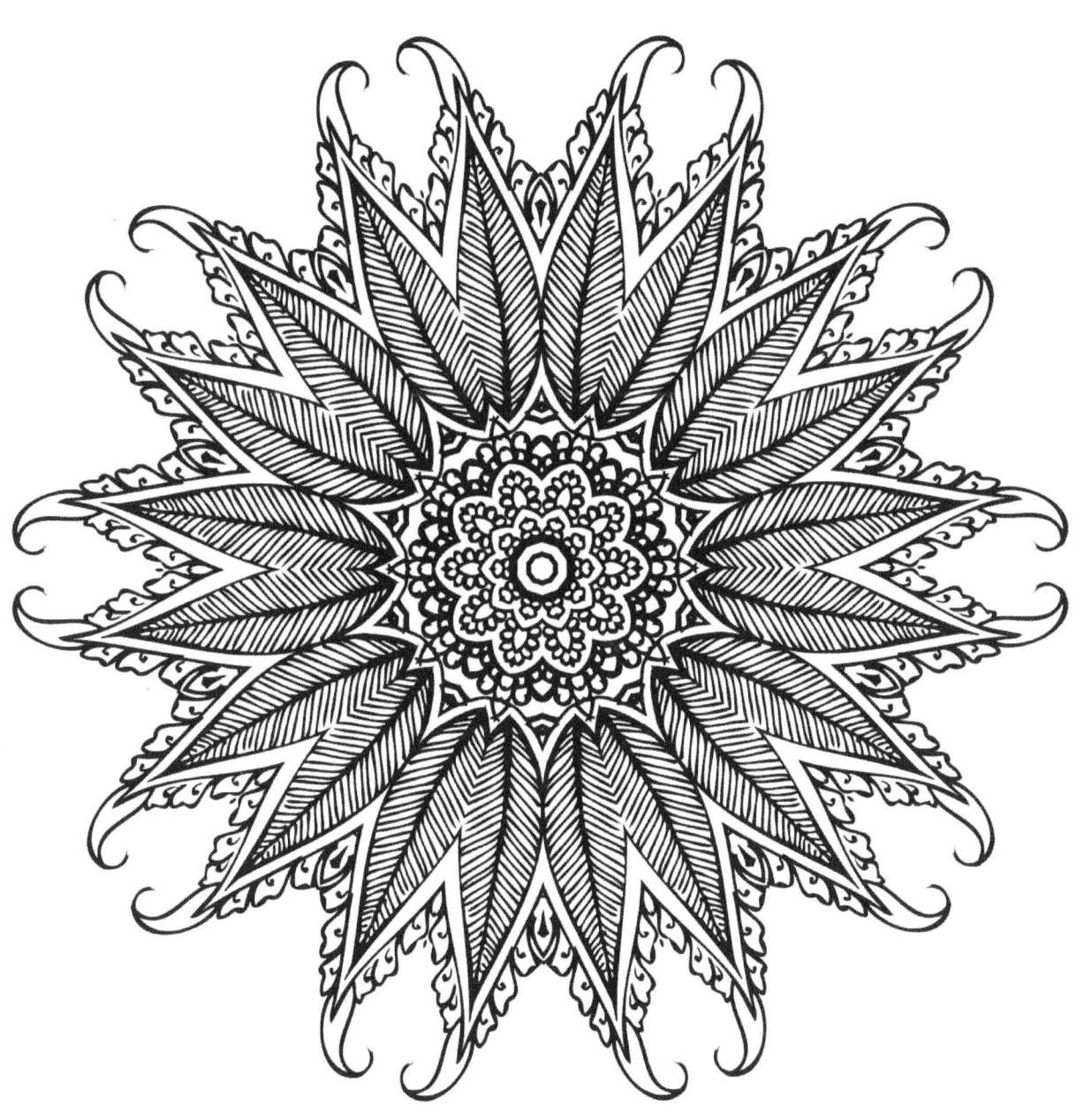

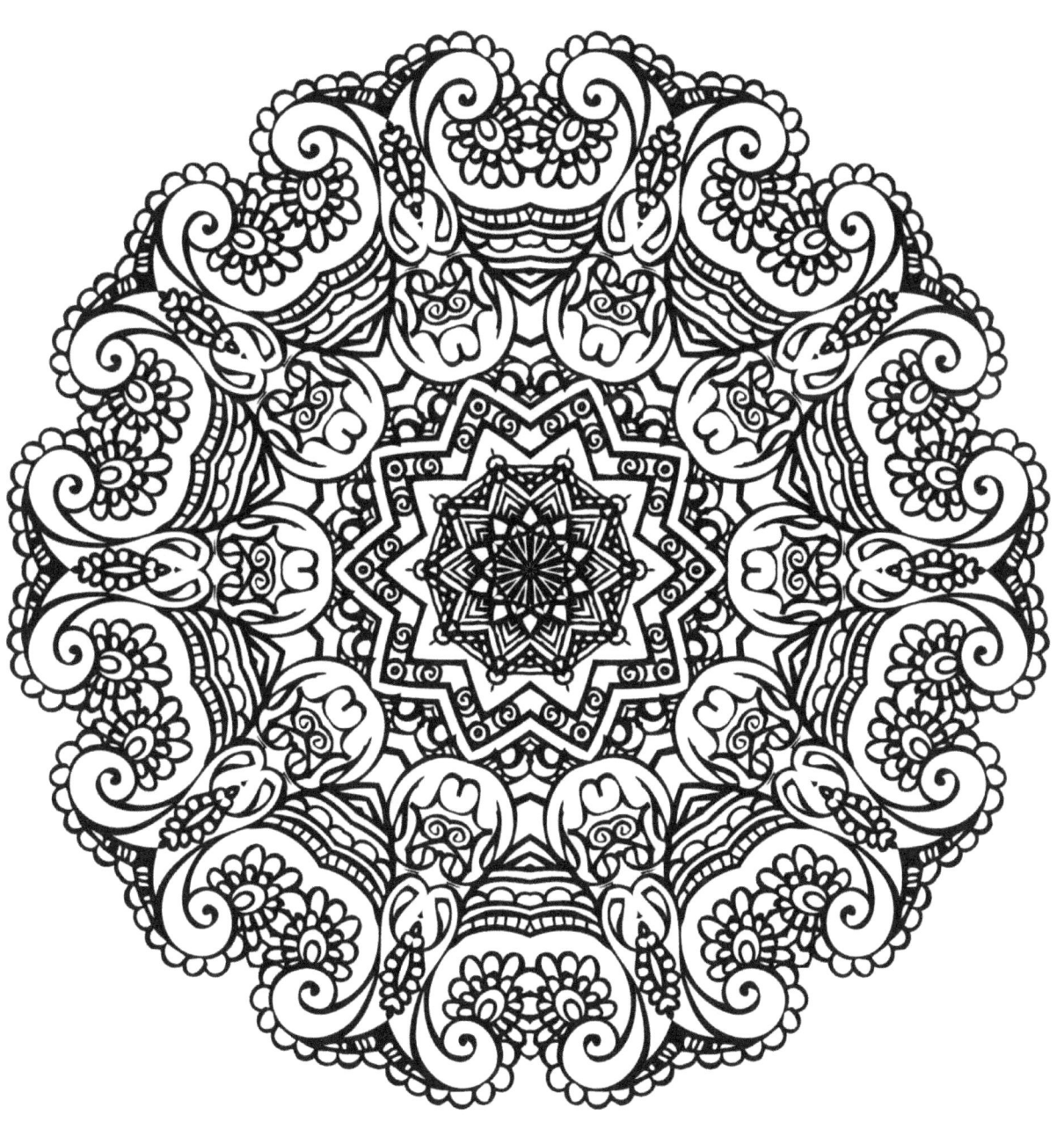

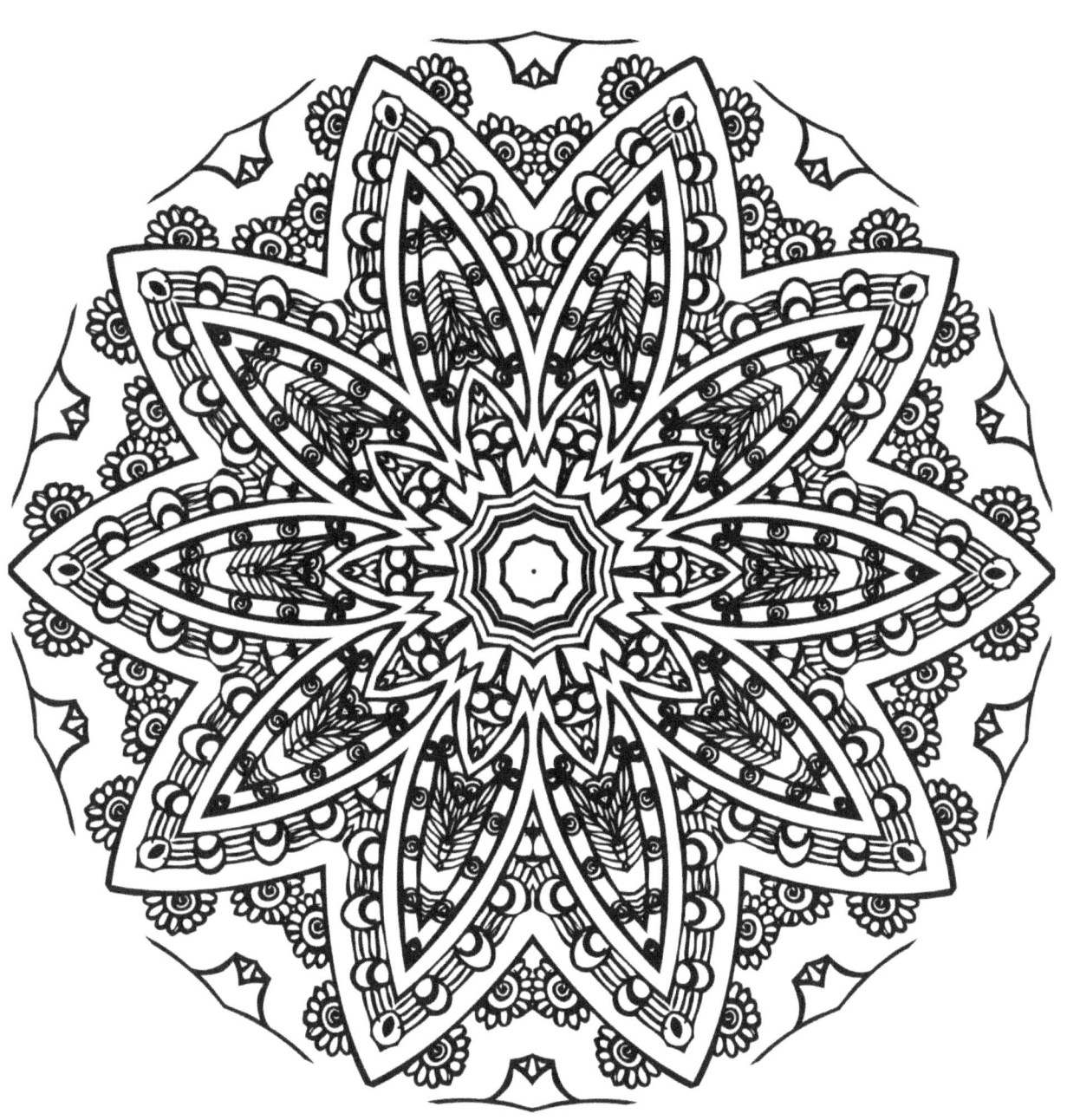

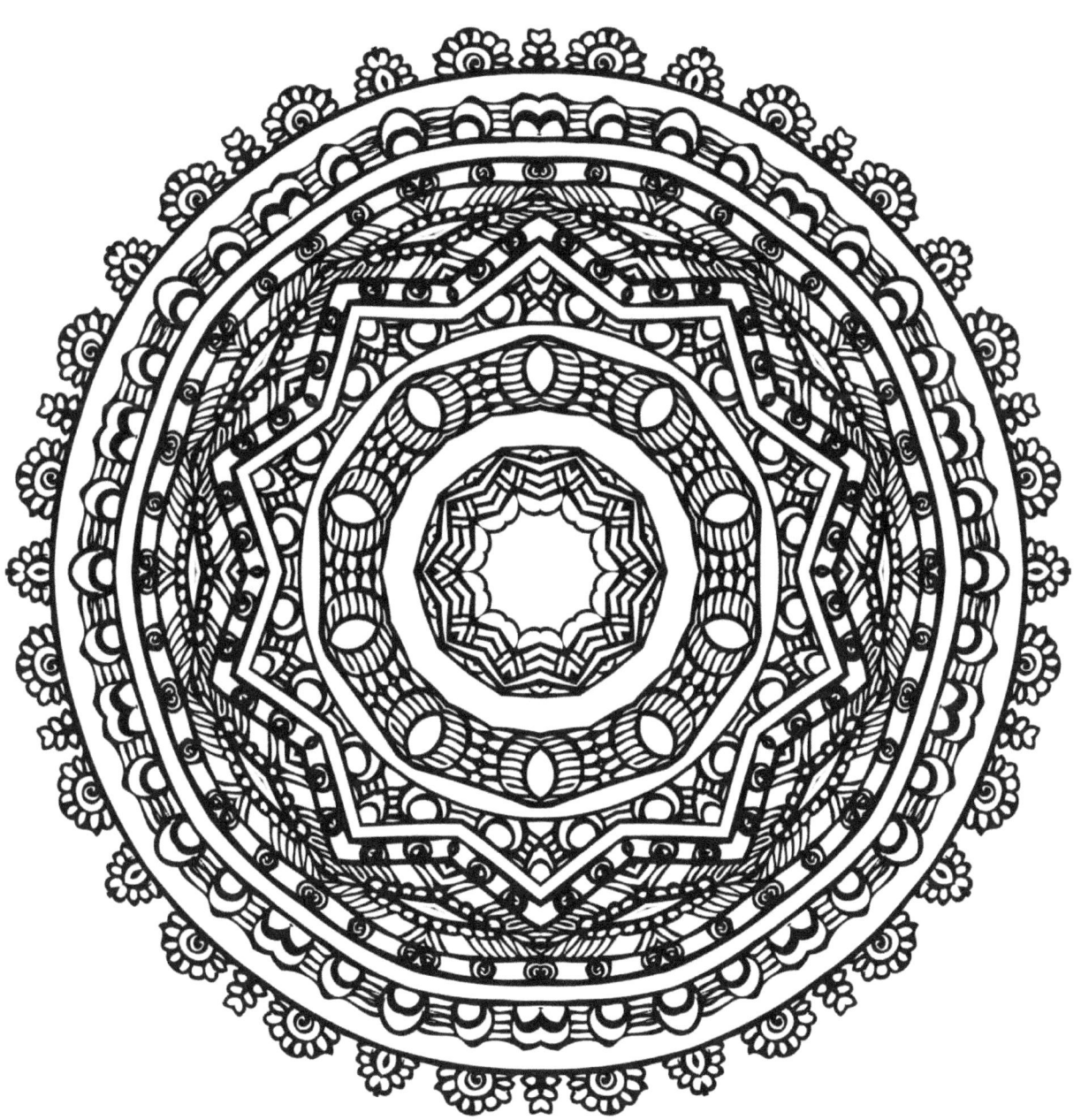

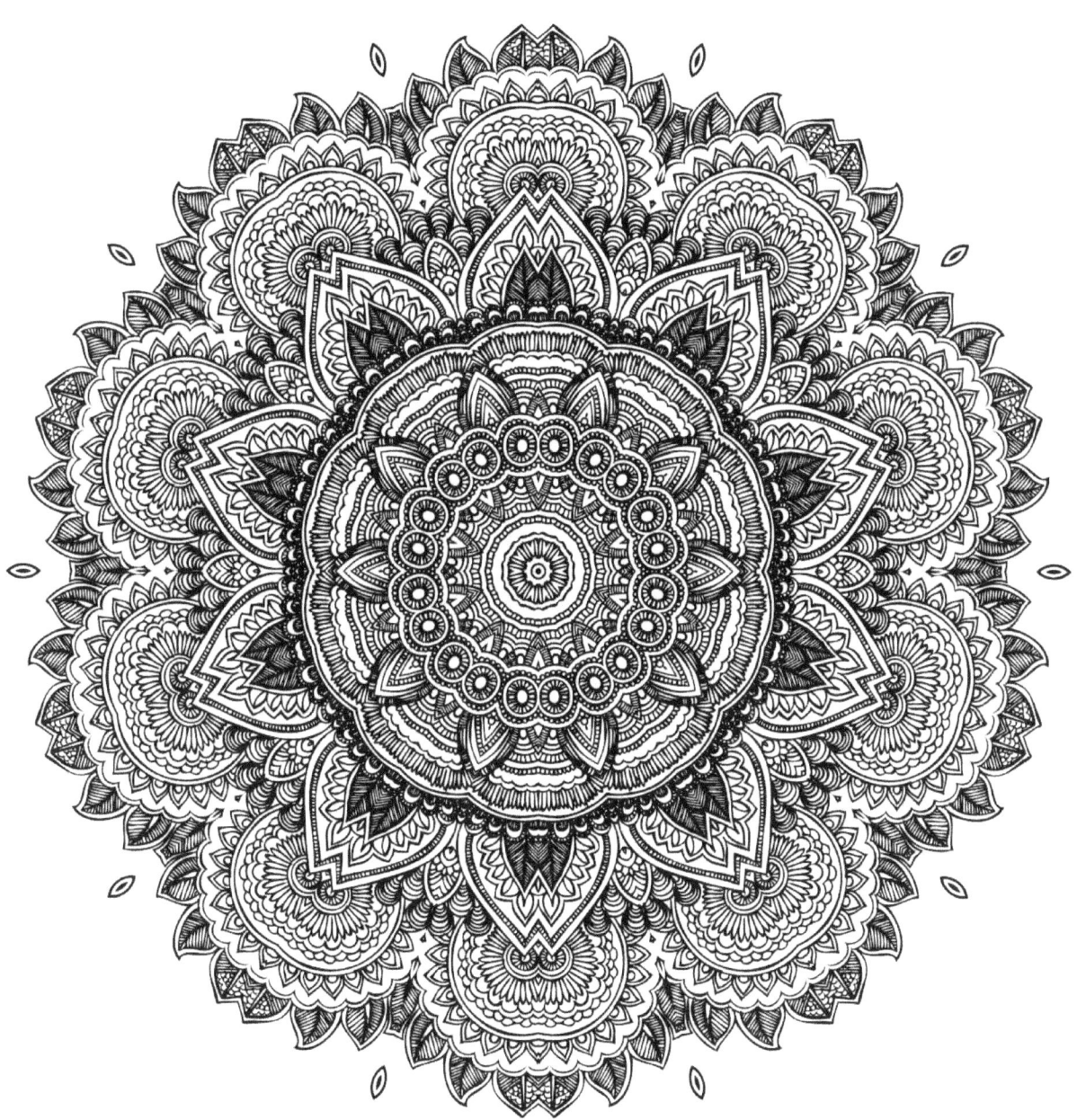

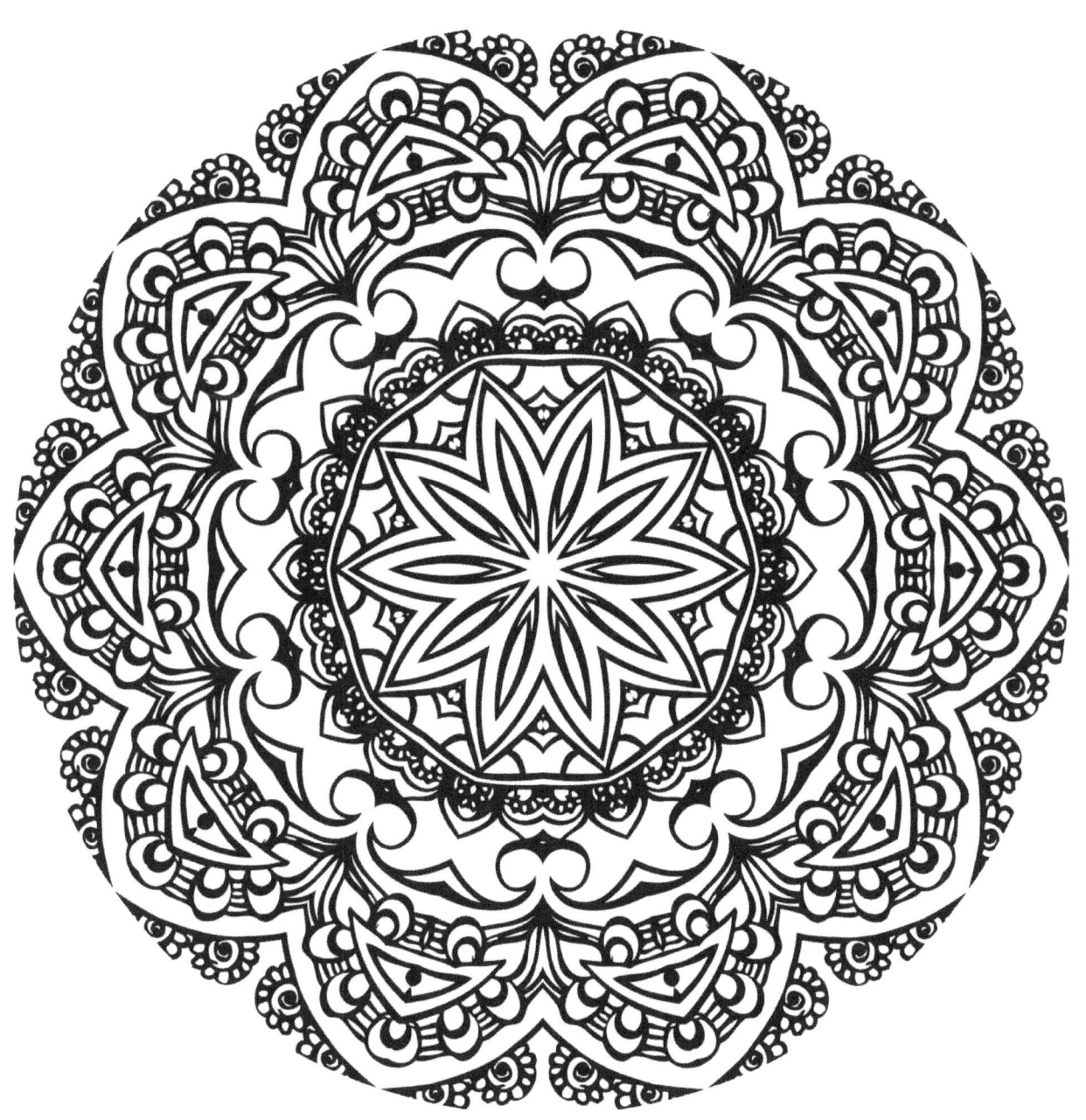

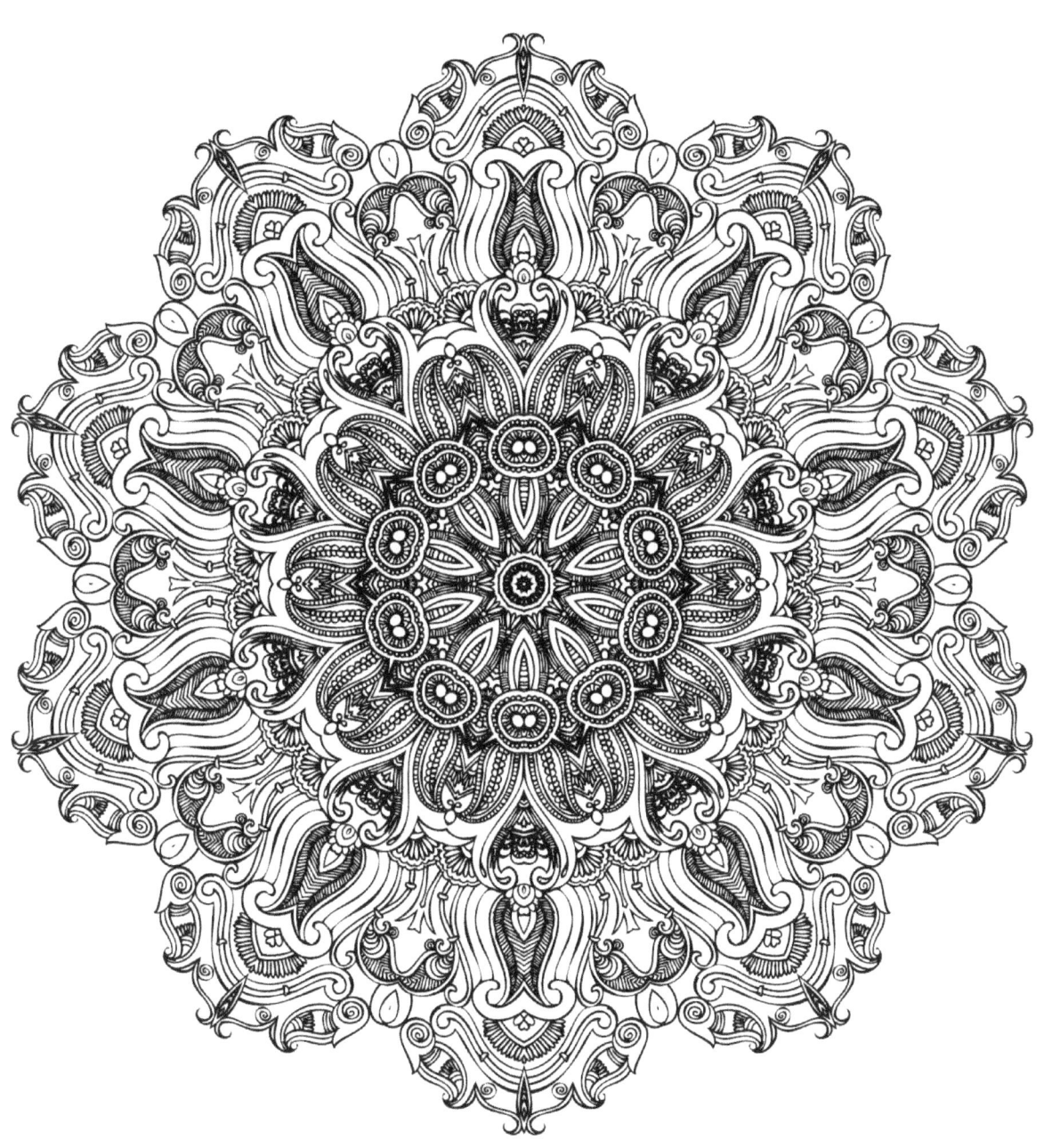

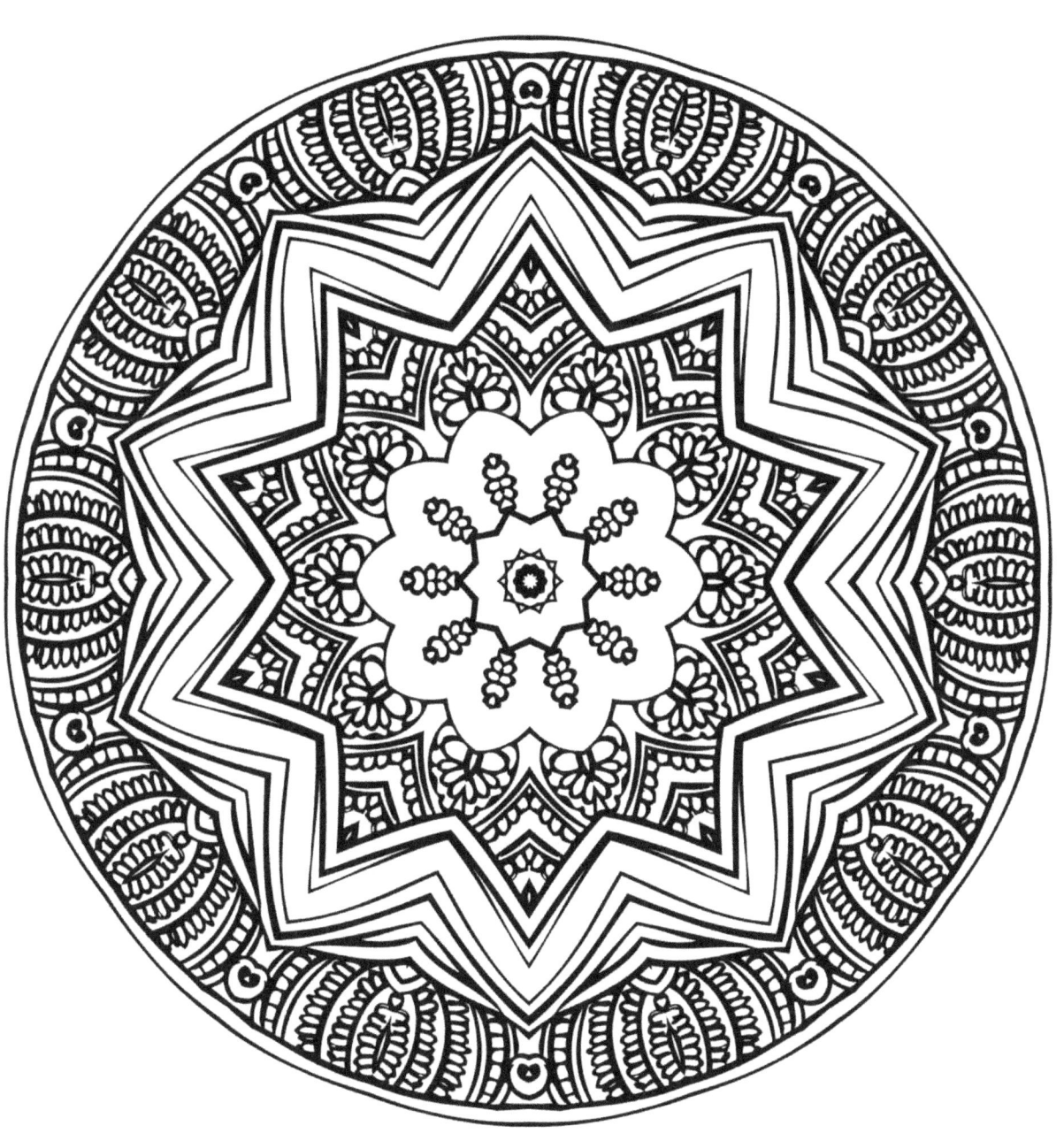

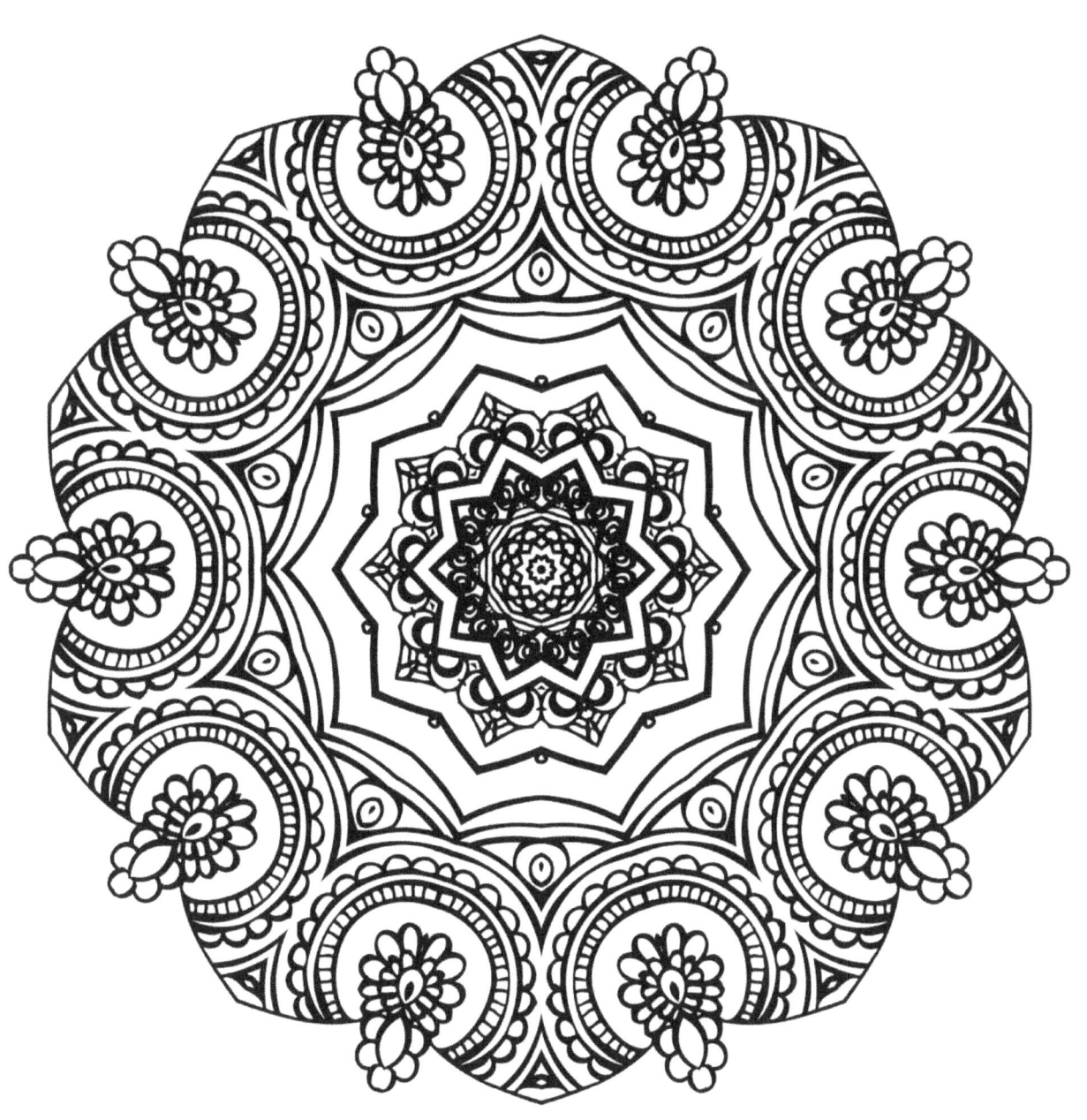

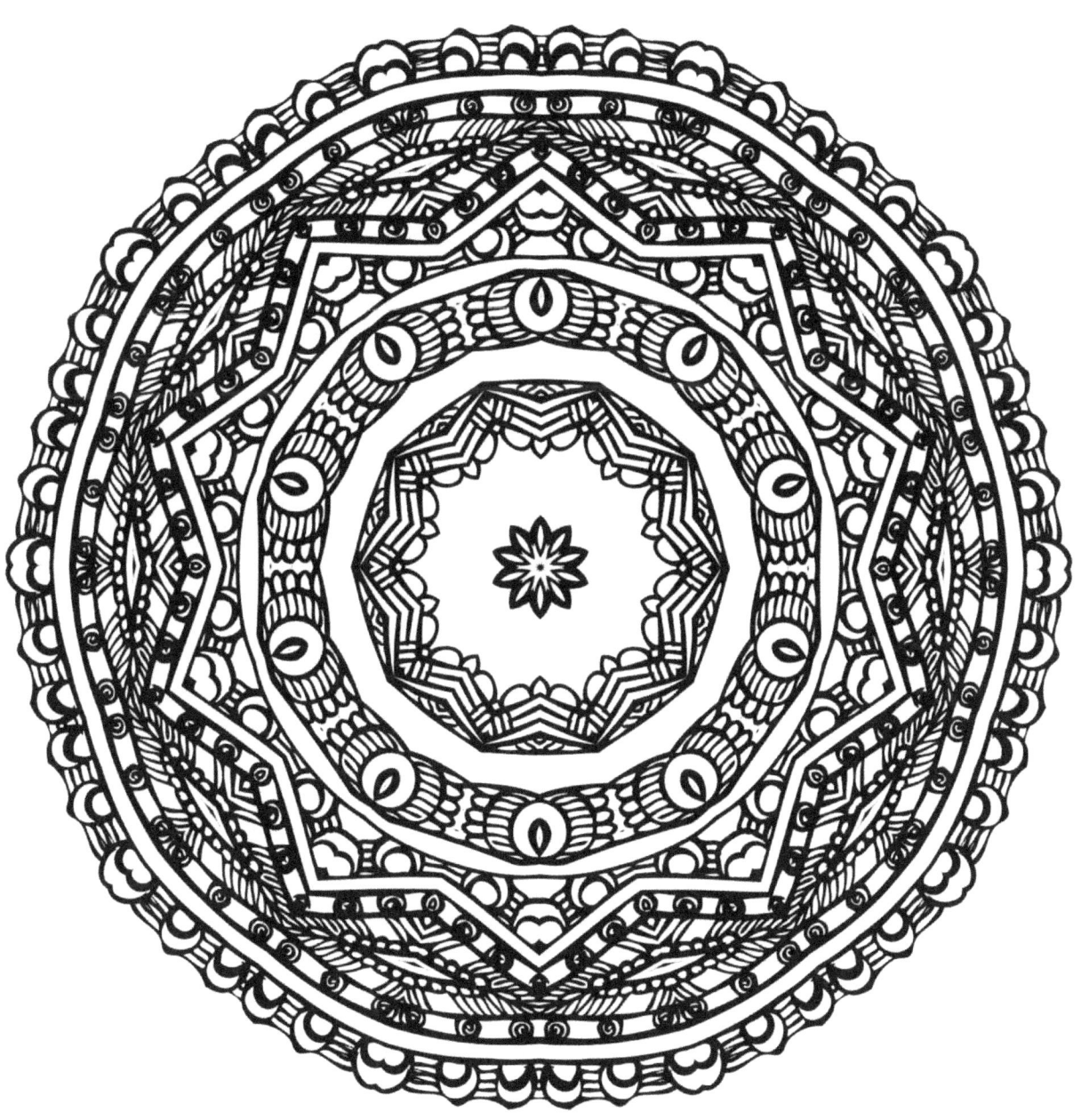

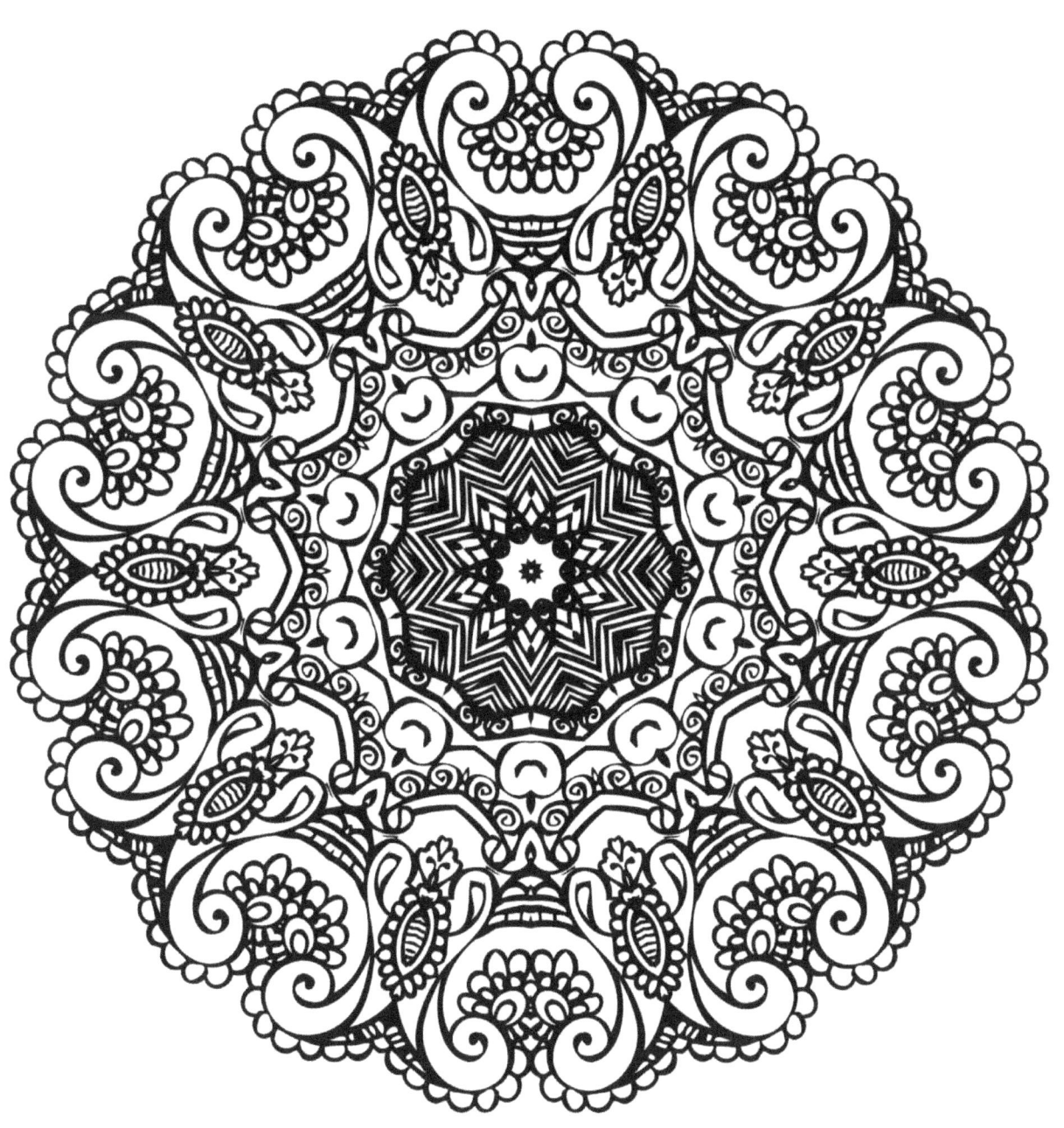

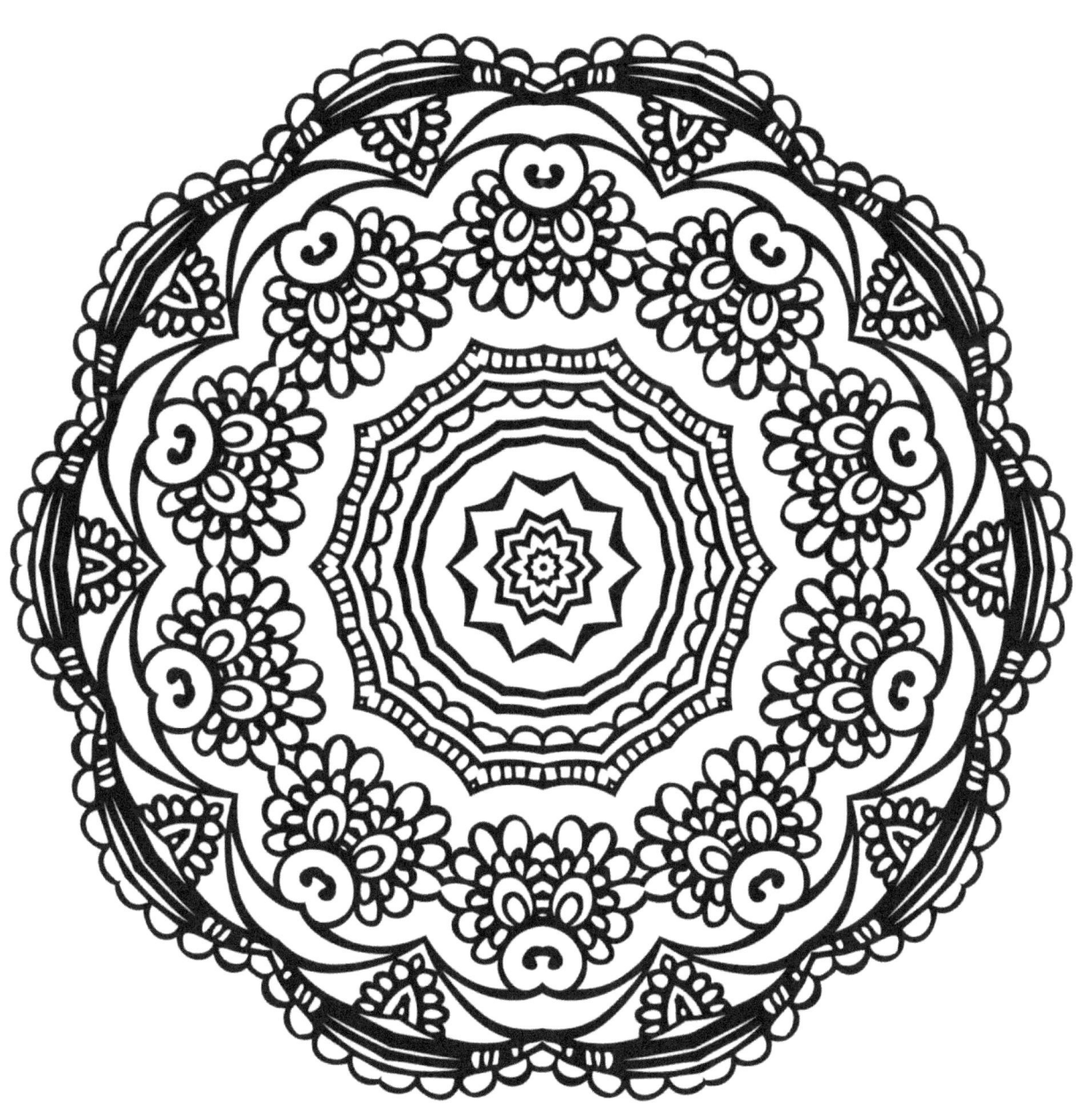

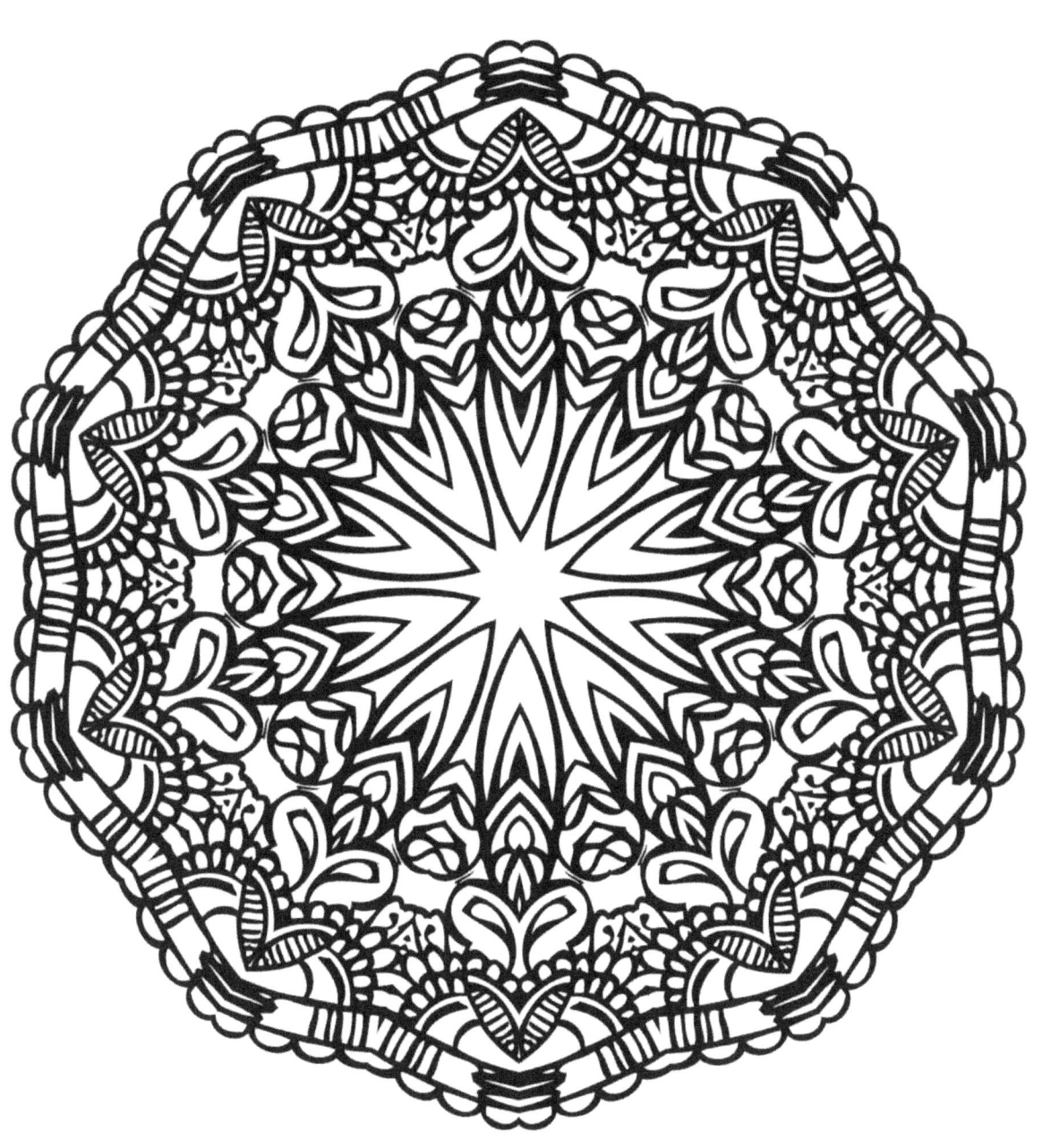

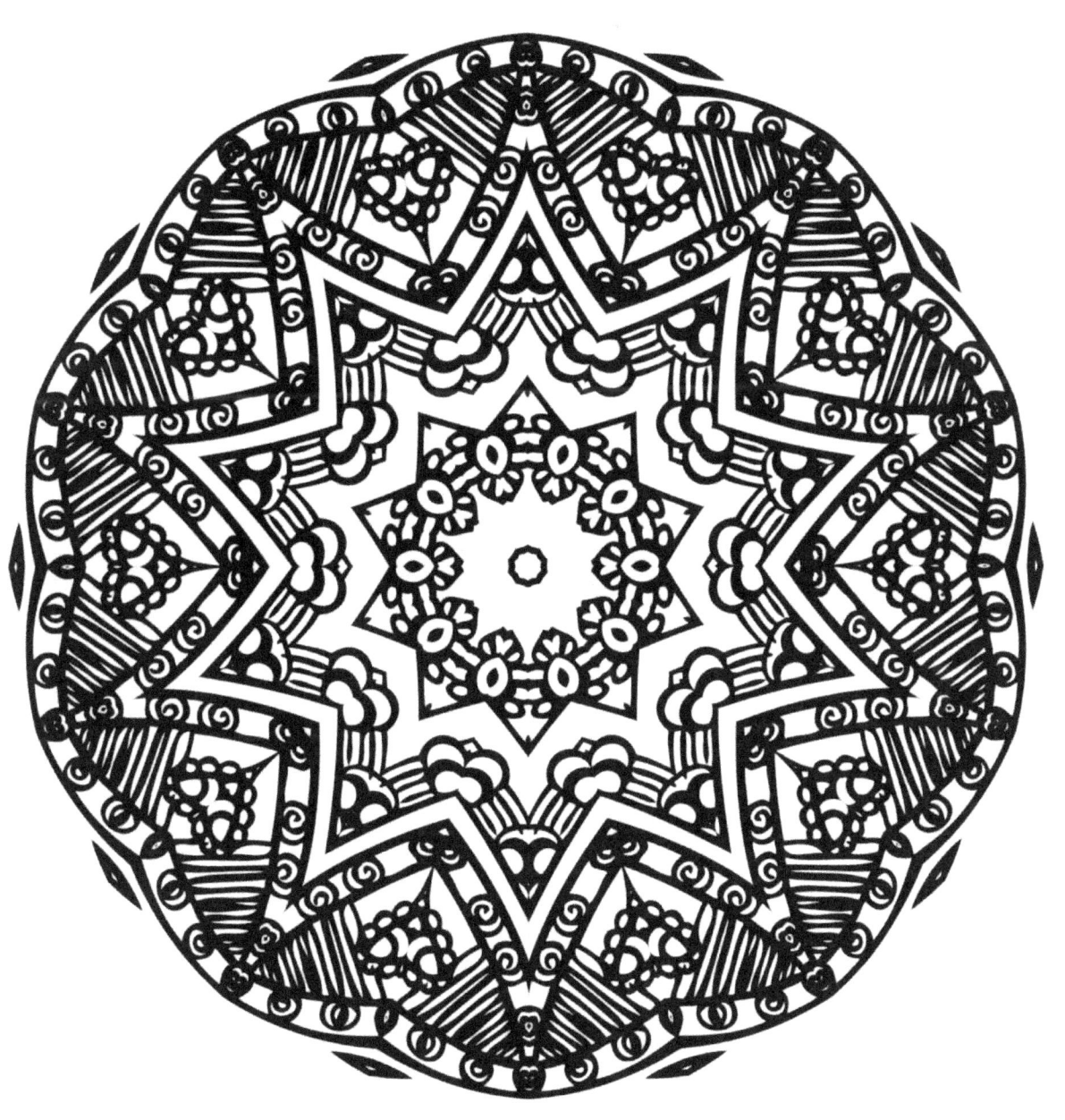

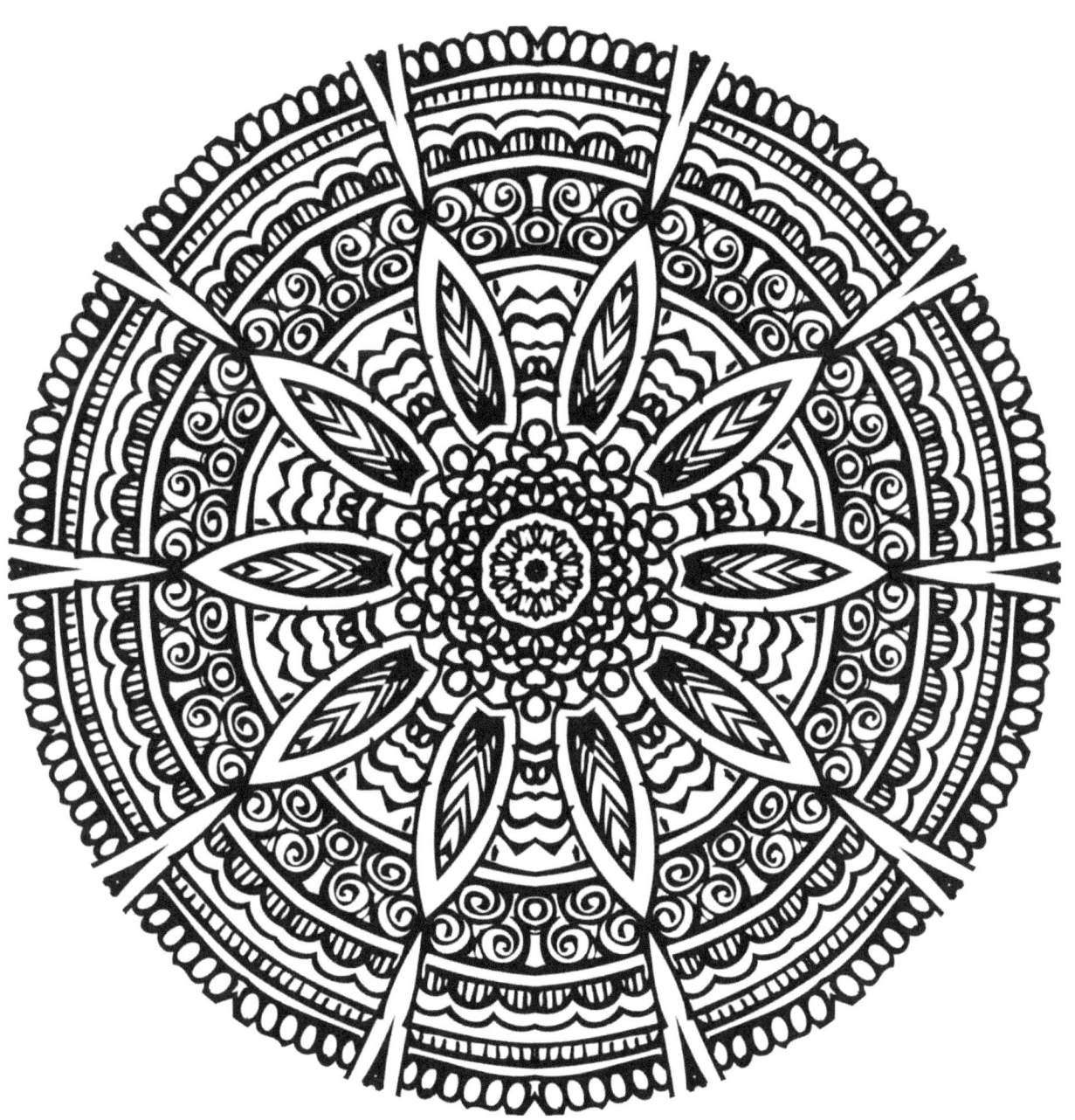

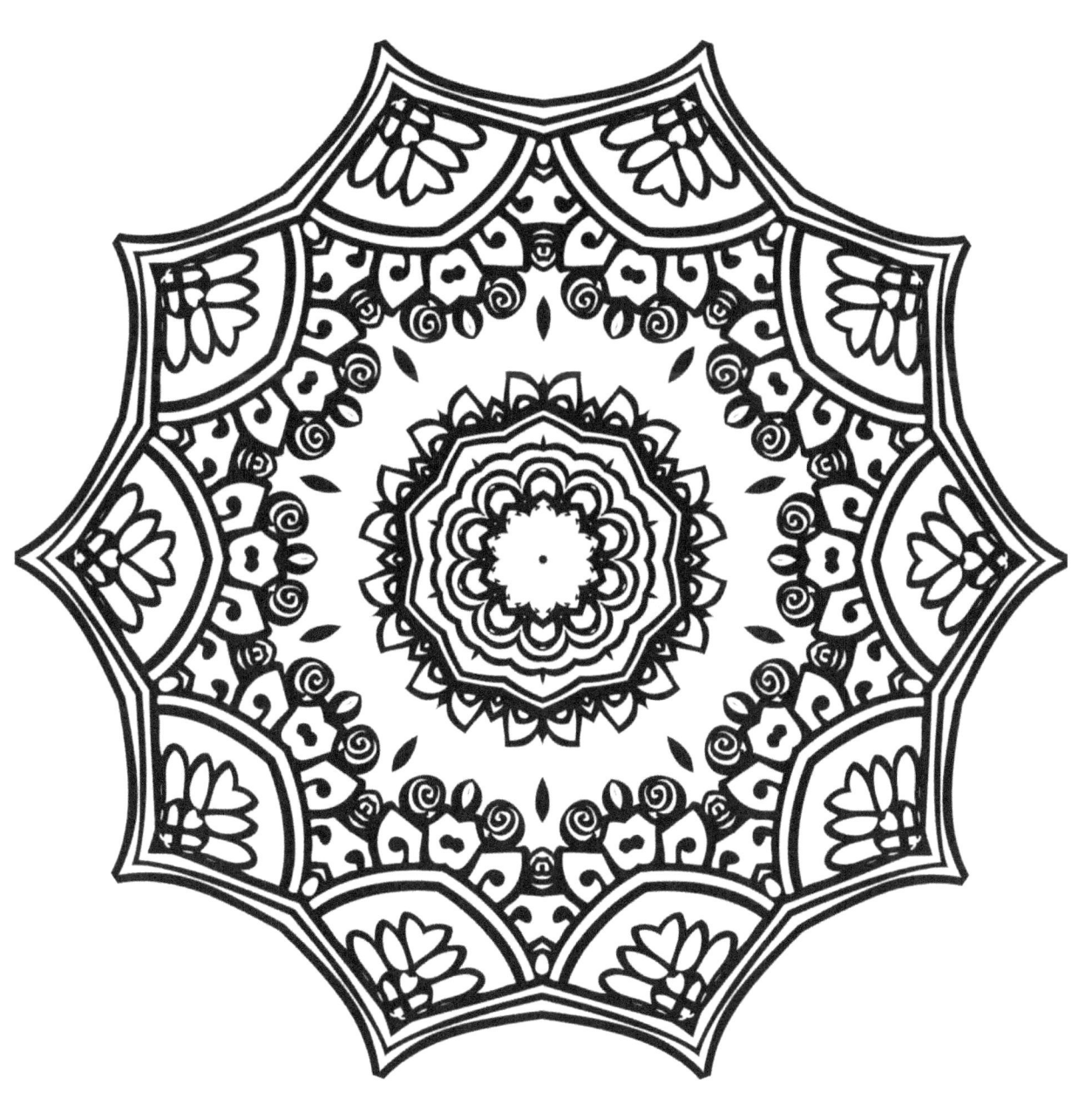

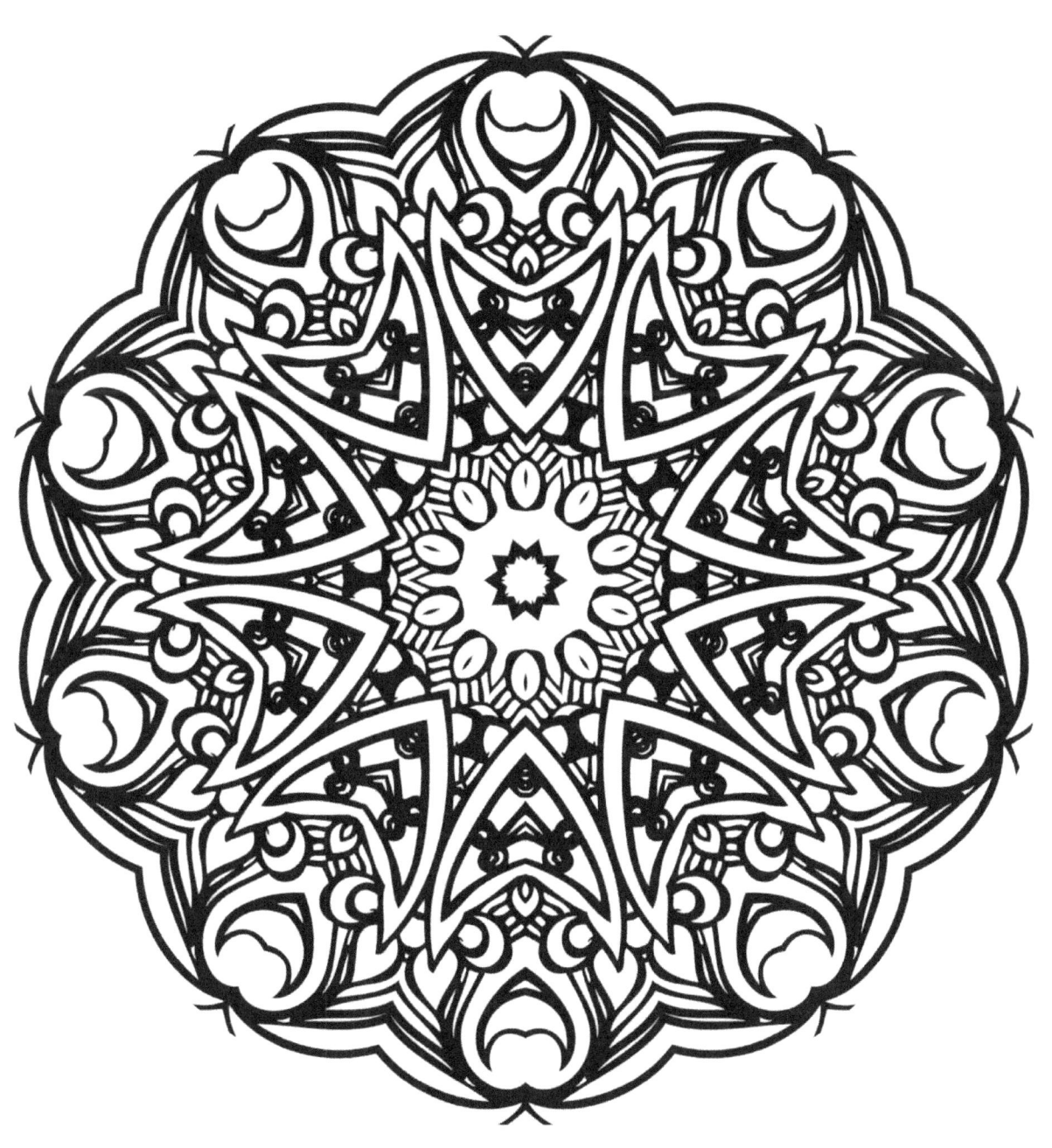

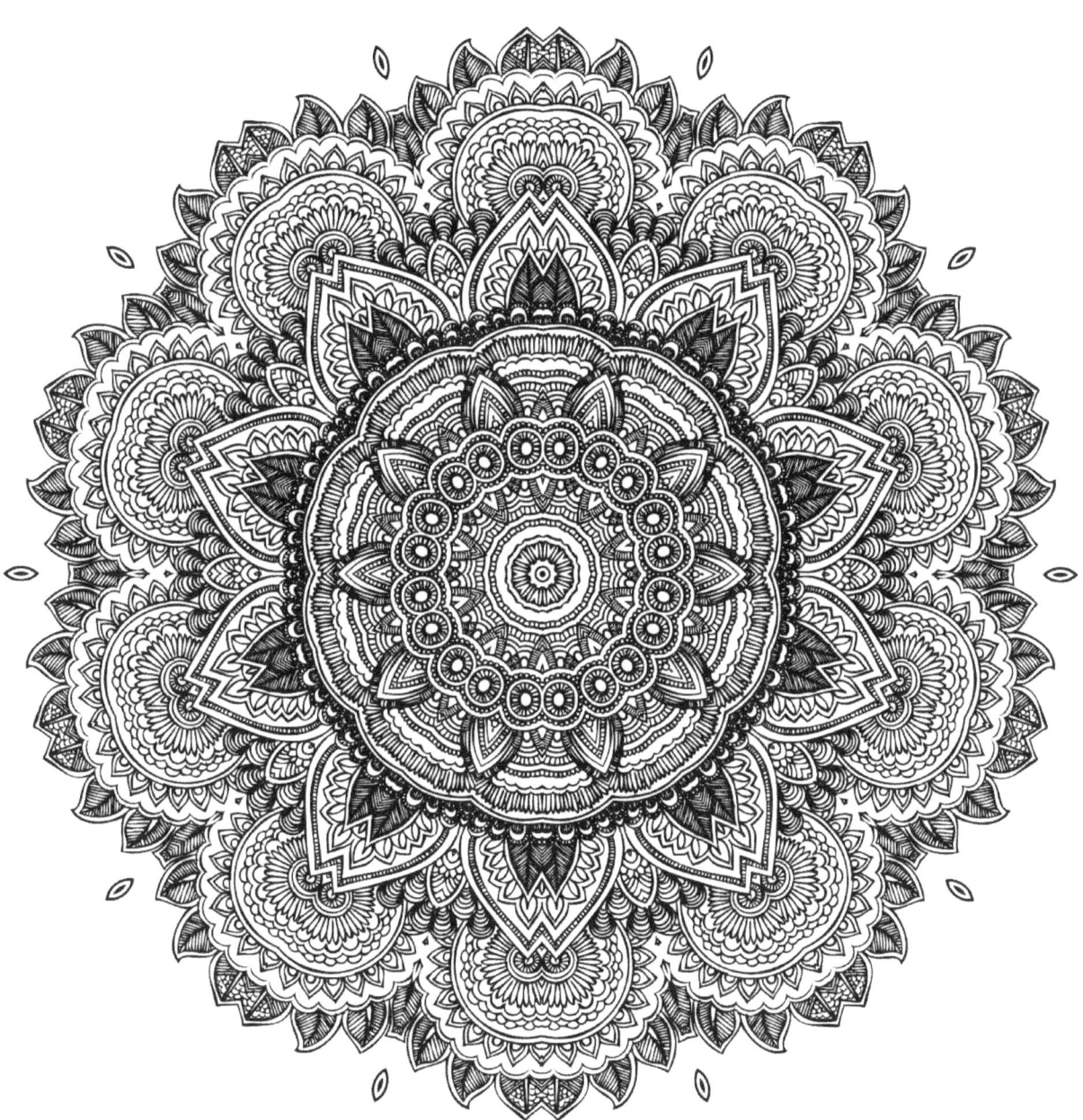

Resources

Art Therapy Journal of the American Art Therapy Association

Articles:

"Can Coloring Mandalas Reduce Anxiety?"

Nancy A Curry B.A and Tim Kasser Phd – April 22, 2011

"Can Coloring Mandalas Reduce Anxiety? A Replication Study"
Renee van der Vennet and Susan Service – June 13 2012.

www.ingramcontent.com/pod-product-compliance
Lightning Source LLC
Chambersburg PA
CBHW080543190526
45169CB00007B/2617